Fadi

Rebecca Evans

BookLeaf Publishing

Fading © 2022 Rebecca Evans

All rights reserved.

Presentation by *BookLeaf Publishing*

Web: www.bookleafpub.com

E-mail: info@bookleafpub.com

ISBN: 978-93-95088-21-3

First edition 2022

DEDICATION

I am dedicating my book to my big brother, Shaun. He was all I've ever known. My best friend from the day I was born. With us being close in age, we were fortunate enough to share the same friends, to experience life together as we grew. When I met my husband, Paul, Shaun quickly became his best friend, with the two of them doing everything together. When I then became a mother to 3 beautiful children, Shaun was a hands-on uncle, who adored his nieces and nephew. We would see Shaun multiple times a week, and he was always available to help, nothing was ever too much trouble for him. He had a heart that even the angels would envy. He passed away suddenly on 30th of December 2021, and my heart will never recover.

ACKNOWLEDGEMENT

To my brother, Shaun Ellis, who passed away suddenly at the age of just 29.
To my husband, Paul Evans, who has helped me survive my loss and supported me through this venture

Pain.

I keep moving, despite the anchors heavy on my
feet,
I struggle to run on the wet, slippery concrete.
My phone is still ringing, but I have no words to
answer,
I just have to get there, I need to move faster.

I feel myself stumble, and I fall to my knees,
Two teenage boys watch me, they laugh and
they tease.
I drag myself to my feet, I'm not in pain,
I'm not hurt on the outside, but I still begin to
wail.

I run through his door, and my legs give way
beneath me,
I am frozen in time, I feel the whole world
change instantly.
I'm panting and crying, my whole body is
shaking,
I find myself praying to a God I don't believe in.

My dear husband, my hero, the best,
He's desperately pushing down on my brothers
chest.

He's been trying for thirty minutes, and he knows it's over,
But he refuses to give up, and keeps his composure.

The rest of us crumble, and scream, beg and cry,
Please don't let my brother die.
The medics arrive, and try to help with my brothers revival,
But a doctor comes to tell us there's little chance of survival.

I hear what he's saying, but I don't understand,
Please, keep trying, I want to demand.
I know, deep down, my pleas would be in vain,
And all that's left for me now, is a lifetime of pain.

Middle child

The middle child became the oldest,
A role she would like to retire,
She struggled to adjust,
To the job she did not desire.

Her life was simple,
Her place was established,
She was happy in the middle,
But that role has now vanished.

Sandwiched between two,
Not the oldest, not the youngest,
One thing she knows is true,
She must now be the strongest.

As much as she tried, she failed to not resent
him,
The day he made her the oldest sibling.

Summer days.

One shallow river, sparkling in the sun,
Two mischievous teenage siblings,
Three bottles of intoxicating tipple,
Four adventurous friends.
Together, they sat, playful and prankish,
The warm, cloudy water against their feet,
They swigged their cider, underage and careless,
But unafraid of the dangers,
Fearless was the sister, the brother was valiant
and bold,
They were always safe together,
On those warm, summer days.

Time limit.

You see, the world moves on quicker than you,
For them, it becomes old news,
Society no longer cares what you've been
through.

People who still sympathize, there will be few,
You'll be told to get back to normal,
You see, the world moves on quicker than you.

Discussing the departed will become a taboo,
You've had time to grieve, now it's time to let go,
Society no longer cares what you've been
through.

You'll lie awake at night, with only your
memories to cling to,
For them is was months ago, for you it was
yesterday,
You see, the world moves on quicker than you.

You'll feel like their lives were of little value,
Nobody wants to know about your pain
anymore,
Society no longer cares what you've been
through.

If you need anything, let me know, is what they
will tell you,
What they don't say is that offer has a time limit,
You see, the world moves on quicker than you.
Society no longer cares what you've been
through.

Incomplete

Christmas he was here, by New Years he had
been stolen,
His father is lost, his mother is broken,
His sisters are stuck in a nightmare that they
cannot wake from
You see, grief is like a wound that will often
reopen.
Despite his passing, his love remains unbroken,
But there are so many words still left unspoken.

Shaun's words

If he were able, what would he say?
Dear father, don't wish your life away.
Dear mother, don't shed tears for me, I promise I
am okay.
To my little sisters, don't be led astray,
Live your lives, in the best possible way.
I am still here, I haven't gone away,
I am still with you, and that's where I'll stay.
Don't bawl for me, I'll see you again one sunny
day,
Until then, please keep your heads up, and live
for today.

Brother.

Silent brother
He is everywhere
And yet he is nowhere at all
Undeniably he surrounds me
Never to be seen again.

Uncle Shaun

They looked for you as babies,
They still look for you now,
They don't understand what death means,
It's a thought their little minds won't allow.

They could get what they wanted, with just a
little whimper
You loved and spoiled them like your own,
They had you wrapped around their little
fingers,
A love that could not be outgrown.

They don't know why you left,
They still think they'll see you soon,
It's hard for them to accept,
That Uncle Shaun is on the moon.

Hell

They don't die just once,
They will die every day.
You'll wake to a fresh hell each morning,
The grief will flood back in waves.

Baby blue eyes

Those baby blue eyes,
They won't leave my head,
Eyes that have closed forever,
I wish they were mine instead.

I try to be the healer,
But that's just my disguise,
I'd willfully die just to see
Those baby blue eyes.

Their future

You'd be helping them to choose their paths
Ten years from now,
But they are left with me to assist,
And I'm not sure I know how.

They needed you to guide them
And I needed you more,
Though I know we are the fortunate ones,
Who have so much to be thankful for.

But I am selfish, and I want you back,
With you, their futures would be bright,
I fear I can't do this without you.
I know you would have raised them right.

The Grim Reaper

When someone you love is in heaven,
You're not afraid to die,
You'll welcome death and seize the chance,
To once again see them smile.

You'll wish you could go with them,
You'll live more recklessly,
Like zoning out whilst driving,
Or in a sixty doing thirty.

The Grim Reaper won't frighten you,
You'll wait for him, happily,
He'll wrap you up with open arms,
And end your agony.

Moving on

The world keeps turning,
They don't care for your trauma,
It's just you hurting.

Normal

Get back to normality they will say,
But they couldn't be more wrong,
There is no normality any more,
And I just can't move on.

Too soon

The warmest smile,
The most gentle soul,
The purest heart,
Left with a piece of us all.

A life narrowly lived,
A body barely aged,
Eyes hardly seen,
And a family left damaged.

Dread.

I find myself pulling up outside your home,
It looks so dark and empty inside,
A site once filled with warmth and love,
A home you made, and the place you died.

The blood rushes to my head,
It's pounding with every breath,
I cry so much I start to heave,
And my heart beats out of my chest.

My palms start sweating,
As I think back to that dreaded day,
I scream your name, over and over,
And I wonder if my pain will ever go away.

Worthy of life.

Some people live to ninety,
Some people don't live to see thirty,
Who decides who lives and who dies?
And who is worthy?

Cheated.

It's always us against the world,
and never us against each other
You're always on my team,
It's your job as my big brother.

My friends are all your friends,
They were only my friends before,
But since introducing them to you,
Well, I guess they like you more.

You meet my husband and don't give 'the
speech',
You're just far too polite,
Instead you take one look at him and say,
"if you wanna be with my sister, it's alright"

You always cover for me with mam and dad,
whenever I break the rules,
You'll have my back no matter what,
Whether I'm stealing cigarettes or skipping
school.

It's supposed to be this way forever,
but unfortunately we were cheated.
I'll cherish all my memories of you,
The way you made sure I was treated.

Infinity

We are everywhere, and yet nowhere at all.
Our conscience is infinite.
We surround you, yet we are not visible.
Our soul lingers on.

Broken.

Sleeping, forever.
Heart failure, they say.
A broken family left behind.
Unrelenting pain.
Never to recover.

Lightning Source UK Ltd.
Milton Keynes UK
UKHW020745190822
407505UK00007B/1222